Sister Wendy Beckett went straight from school to the novitiate of an active teaching order, which sent her to Oxford and then engaged her in its schools and at a university. Her longing to spend her time in prayer was finally answered when she was 40 and she was allowed to lead a contemplative life under the protection of the Carmelites. She has spent her time in prayer ever since, which includes making programmes on art for the BBC and writing books on art, on icons and on prayer. Now, nearing the end of her life, she is a deeply content and grateful woman.

The Art of Lent

A painting a day from Ash Wednesday to Easter

Sister Wendy Beckett

InterVarsity Press, USA
P.O. Box 1400
Downers Grove, IL 60515-1426, USA
ivpress.com
email@ivpress.com

Society for Promoting Christian Knowledge
36 Causton Street
London SW1P 4ST, England
www.spck.org.uk

InterVarsity Press®, USA, is the book-publishing division of InterVarsity Christian Fellowship/USA® and
a member movement of the International Fellowship of Evangelical Students. Website: intervarsity.org.

SPCK does not necessarily endorse the individual views contained in its publications.

Unless otherwise noted, Scripture quotations are taken from the New Revised Standard Version of
the Bible, Anglicized Edition, copyright © 1989, 1995 by the Division of Christian Education of the
National Council of the Churches of Christ in the USA. Used by permission. All rights reserved.

The quotation marked NASB is from the NEW AMERICAN STANDARD BIBLE®, Copyright © 1960, 1962,
1963, 1968, 1971, 1972, 1973, 1975, 1977, 1995 by The Lockman Foundation. Used by permission.

Interior design: © SPCK
Images: The Tower of Babel – Pieter Bruegel the Elder / Alamy Stock Photo

USA ISBN 978-1-5140-0426-5 (print)
UK ISBN 978-0-281-07855-4 (print)
UK ISBN 978-0-281-07856-1 (digital)

Typeset by Fakenham Prepress Solutions, Fakenham, Norfolk NR21 8NL
First printed in the UK by Micropress

Printed in Turkey ♻

InterVarsity Press is committed to ecological stewardship and to the conservation of natural
resources in all our operations. This book was printed using sustainably sourced paper.

British Library Cataloguing-in-Publication Data
A catalogue record for this book is available from the British Library.

Library of Congress Cataloging-in-Publication Data
A catalog record for this book is available from the Library of Congress.

P 25 24 23 22 21 20 19 18 17 16 15 14 13 12 11 10 9 8 7 6 5 4 3 2 1
Y 36 35 34 33 32 31 30 29 28 27 26 25 24 23 22 21

CONTENTS

WEEK 3 PEACE

WEEK 4 JOY

WEEK 5 CONFIDENCE

WEEK 6 LOVE

The Art of Lent

ASH WEDNESDAY

Repentance

The Great Wave, 1831, Katsushika Hokusai

We cannot control our life. As Hokusai shows so memorably, the great wave is in waiting for any boat. It is unpredictable, as uncontrollable now as it was at the dawn of time. Will the slender boats survive or will they be overwhelmed? The risk is a human constant; it has to be accepted – and laid aside. What we can do, we do. Beyond that, we endure, our endurance framed by a sense of what matters and what does not. The worst is not that we may be overwhelmed by disaster, but to fail to live by principle. Yet we are fallible, and so the real worst is to forget our fallibility, to refuse to recognize failure and humbly begin again.

Ash Wednesday reminds us of our constant need to acknowledge and confess our fallen humanity, to repent of the past and throw ourselves on the loving mercy of God. For we have been assured that nothing can separate us from the love of God in Christ Jesus our Lord (Romans 8.38–39).

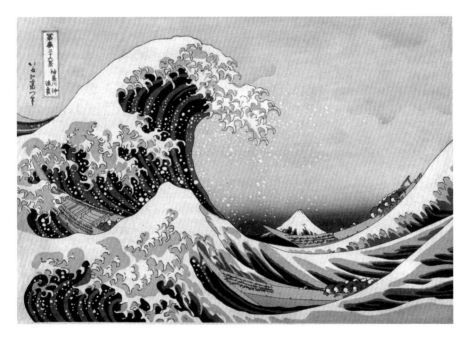

THURSDAY

Forgiveness

The Return of the Prodigal Son,
c.1661–69, Rembrandt van Rijn

If we had nothing of Jesus' teaching, except this one parable, we would still understand his message of love. It is his supreme example of the immensity, almost the folly, of God's love for us. Rembrandt, most tender of painters, is sensitive to every nuance of the prodigal's return. This is the bad son, the wilful spendthrift, who cared nothing for his father or his adult responsibilities while the money lasted. It is only when he is starving and homeless that he returns home. Rembrandt shows him in his ragged humiliation. It is not just that his father receives him back with such compassion: it is the father's eagerness that astonishes us. He is watching out always for this lost child, abundantly ready to lavish upon him the good clothes, the feasting and cherishing, that have been so wilfully disregarded. The other son (is that him on the right?), the good, prim, self-righteous son, cannot understand the father's attitude. Perhaps we cannot understand it either, but this is what it means to love and forgive.

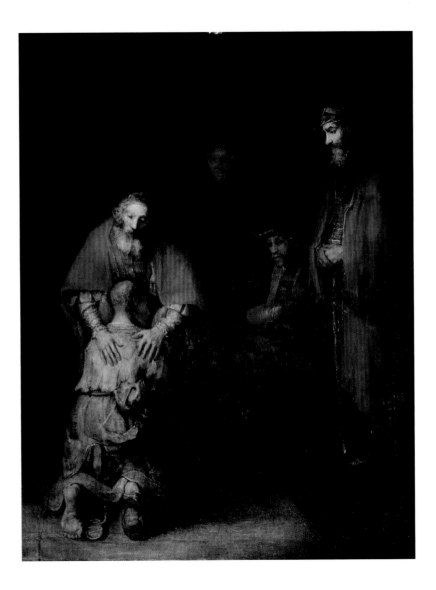

FRIDAY

Humility

Self-portrait with Dr Arrieta, 1820,
Francisco de Goya

As the holiest among us know (in fact especially
the holiest), we are a sick and sinful people. We all
fall short of the glory of God and none of us, to our
grief, can say, 'I do always the things that please
him.' In this wonderful self-portrait the ageing Goya
looks without illusion at his state of sickness. It is
this clear, hard, realistic look at ourselves that we all
need. But Goya also shows that he is not alone. His
beloved doctor friend is with him, comforting him,
healing him, in fact saving him. Skilful though Doctor
Arrieta was, his very look of anxiety reveals that he
knows that he is not all-powerful. But our doctor,
our Saviour, is all powerful. As our Lord himself said,
'Those who are well have no need of a physician,
but those who are sick; I have come to call not the
righteous but sinners' (Mark 2.17).

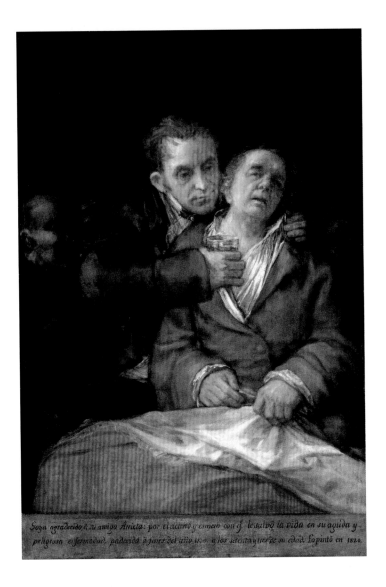

Goya agradecido, á su amigo Arrieta: por el acierto y esmero con q.^e le salvó la vida en su aguda y peligrosa enfermedad, padecida á fines del año 1819, á los setenta y tres de su edad. Lo pintó en 1820.

SATURDAY

Purification

The Harvest is the End of the World and the Reapers are Angels, 1989, Roger Wagner

The essential sign that we have grown up is that we can accept responsibility. All actions have consequences, but the consequences may not be visible. Jesus is adamant that he will not destroy the wheat and the tares, that he will let the sheep and the goats pasture together until the time of judgement. None of us is wholly wheat or wholly tare: we are a mixture of both. But every tare we have sown must be destroyed so that we can be pure wheat for God's holy bread. Either we must wait until the time of judgement for the angels to reap God's harvest or we must cooperate with him and do it while we are still alive. Wagner's picture, with a dark, threatening sky and the angels with their sickles, forewarns us of what is to come. We may look over our lives and see a vista like the golden grain, but God knows there are tares hidden there. He will destroy them if we truly desire him to make us pure.

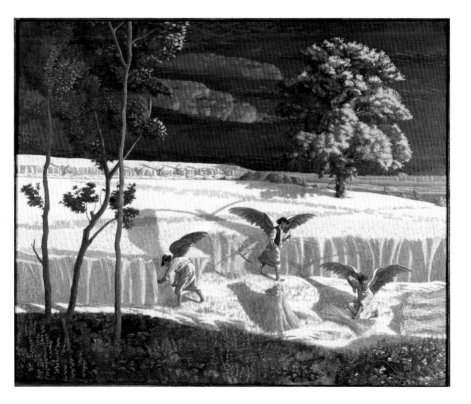

First Sunday in Lent

Silence

For God alone my soul waits in silence.

PSALM 62.1

1

MONDAY

Profound silence

Woman with a Pink, 1665–69,
Rembrandt van Rijn

The capacity for silence – a deep, creative awareness of one's inner truth – is what distinguishes us as human. All of us, however ordinary or flawed, have at heart a seemingly boundless longing for fulfilment, and it is their consciousness of this that makes Rembrandt's portraits so beautiful. The *Woman with a Pink* is lost in the depths of her private reflections. Her dark background is symbolically unimportant, lending greater expression to the soft brightness that plays upon her face. Visibly silent, she is explicitly encountering the mystery of being human. She does not contemplate the carnation (the 'pink'), usually an emblem of love, but looks within, in silence, quiet and engrossed.

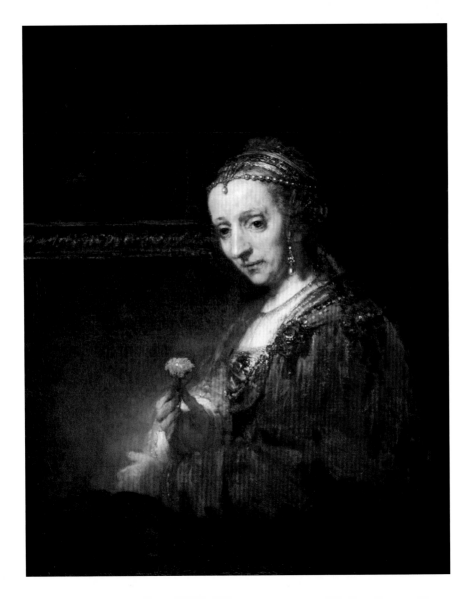

1

TUESDAY

Desiring silence

Holy Island from Lamlash, 1994,
Craigie Aitchison

Profound silence is not something we fall into
casually. This may indeed happen, and a blessed
happening it is, but normally we choose to set aside
a time and a place to enter into spiritual quietness.
(Those who never do this, or shrink from it, run a
very grave risk of remaining half-fulfilled as humans.)
Craigie Aitchison's view of Holy Island pares this
choice down to its fundamental simplicities. Brown
earth, blue sea, red sky, Holy Island a stony grey
lit by glory. There is a small ship to take us across,
if we choose to ride in it. There are no fudging
elements here: all is clear-cut. This is not silence
itself but rather the desire for silence. Silence,
being greater than the human psyche, cannot be
compressed within our intellectual categories; it
will always escape us. But the desire to be silent,
the understanding of the absolute need for it: this
is expressed in Aitchison's wonderful diagram of life
within the sight of the holy.

1

WEDNESDAY

Beyond Babel

The Tower of Babel, c.1563, Pieter
Bruegel the Elder

What silence principally armours us against is Babel:
the endless foolish chatter, words used to confound
thought, words misused to ward off friendship or
attachments, words as occupation. The biblical Babel
was a metaphor for the loss of human ability to
communicate as a consequence of the rise of different
languages; but the foreignness of other tongues is
a smokescreen. To express what one means, and
to hear what another means: this is a rare thing.
Babel is profoundly destructive of our energies, as
Bruegel so splendidly shows. This monstrous tower
is consuming all who labour on or near it. We have
an absolute need for quiet, for the heart's wordless
resting on God.

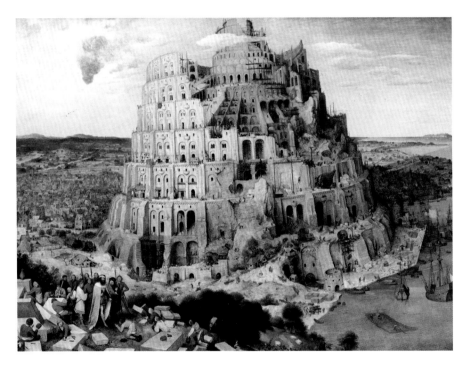

1

Meditative silence

The Magdalen Reading, c.1445,
Rogier van der Weyden

There are layers of silence. Van der Weyden's Magdalen is deeply silent, but she is reading. Her mind is active, and willed into activity. This, then, is a mitigated silence, since we are only receptive to the thoughts of what we are reading. The Magdalen is obviously reading the Scriptures, and meditating on what she reads, but her silence can only be between passages of reading and will be concerned with those passages. If we do not read with intervals of silent reflection, we will understand only in part what we read. This is a fractured silence, good but imperfect. We all need to read, to keep our spirit alert, to have an inner texture, as it were, that can respond to the absolutes of pure soundlessness, but this chosen, meditative layer is the least significant.

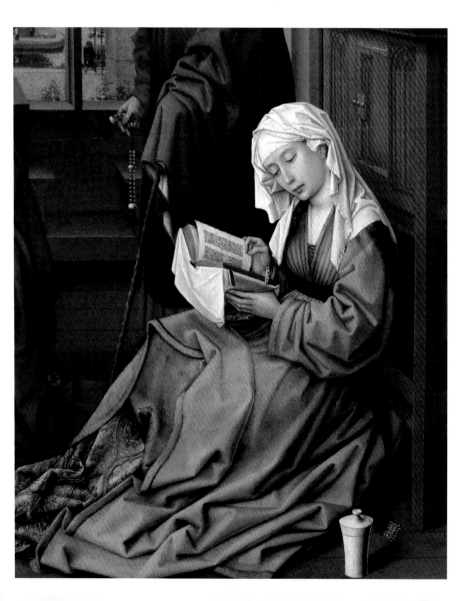

1

FRIDAY

A paradox

Untitled H30 (diptych), 1993,
Rebecca Salter

Silence is a paradox, intensely 'there' and, with equal intensity, 'not there'. The passivity of silence is hard to explain, since in one respect it is intensely active. We hold ourselves in a condition of surrender. We choose not to initiate, nor to cooperate with our mental processes. Yet from this passivity arises creativity. This mysterious liberation from all commonplace worldly demands is exemplified in Rebecca Salter's abstractions, which have been compared to gazing at a waterfall. Salter seems as if to have painted silence itself: the work is both alive and moving, and yet still, so that the eye wanders absorbed and yet patternless, through and among the shapes before us. There is nothing to say, nothing even to experience in any words that sound impressive, yet the looking never wearies. This is a rough image, in its very imagelessness, of the bliss of silence.

1

SATURDAY

Silence and time

Three Greys, 1987, Yuko Shiraishi

A quick glance at *Three Greys* and we might walk away, thinking it drab and over-regulated. A slower glance, and the painting reveals an infinitude of subtle hues and shifting verticals. Its beauty, like so much else we see, reveals itself only in time. Silence is making-friends-with-time. It does not fight it or waste it, it refuses to run after it. Silence floats free with time, letting the patterns of the moments unfold at its own pace. It is a way of becoming free, not only for the practical advantage of being able to 'see' the beauty in what is grey, for example, but at a far deeper level. In silence we break the hold time has on us, and accept in practice that our true home is in eternity.

Second Sunday in Lent

Contemplation

Meditate in your heart . . . and be still.

PSALM 4.4 (NASB)

2

MONDAY

Into the light

Young Woman with a Water Jug,
c.1662, Jan Vermeer

The gate that silence opens up within us leads to
light. Light exposes with an almost merciless radiance
and, in the exposure, reveals the beauty of the real.
Vermeer always painted this holy light. He may seem,
on first looking, to be depicting a young woman,
standing at a half-opened window, wrapped peacefully
in her own thoughts, but she and her surroundings
are merely the pretext. Vermeer's intensity is focused
on the light itself, only visible to us as it falls on the
material world. It shimmers on the woman's white
headdress, glimmers on the copper of the jug and
ewer, glimmers with ineffable softness on the walls.
Every element in the painting celebrates the presence
of light, revealing and transforming. No painter has
ever believed more totally in light than Vermeer –
and hence the profoundly contemplative nature of
his art.

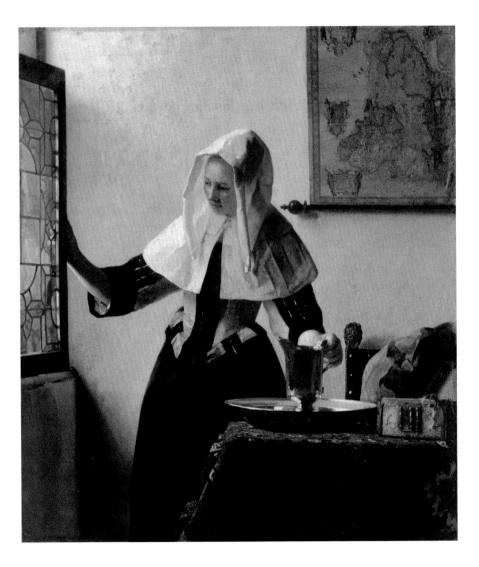

2

TUESDAY

Manifestation

Epiphany, 1990, Robert Natkin

Only the abstract artist can attempt to show us light in itself, free from any material context. This is pure contemplation, the experience removed from the concrete and celebrated as a transforming peace. Epiphany is a Greek word meaning manifestation, a revelation of glory. We are not meant to understand Natkin's picture, any more than we are meant to intellectualize during our periods of contemplation. We become still and enter into silence to let the holiness of mystery take possession of us. We do this not in the absence of thought, but beneath thought. Natkin shows us infinite shades of colour, a constantly receding radiance. The longer we gaze at it, the more we 'see': not in understandable images but in pure experience of chromatic brightness. This undifferentiated experience is integral to contemplation.

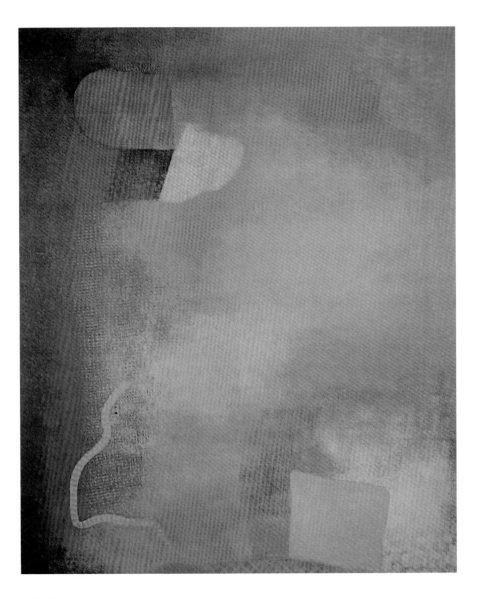

2

WEDNESDAY

The still mind

St Catherine of Alexandria
(cropped), c.1507, Raphael

What matters is not stillness itself, which can be
merely physical, but what we do within it. The great
mystic, Teresa of Avila, called the mind a clacking
mill that goes on grinding. This is the nature of the
mind; to have thoughts. We can indeed still the
mind, through intense psychic application, but such
application – directed wholly to the self – may be
so self-satisfying as to abnegate its very purpose.
The purpose of contemplation is a directed stillness,
which receives rather than acts. There is only one
state of perfect freedom from thought, and that
is ecstasy. Raphael's St Catherine is rapt, lost to
everything but her comprehension of God. She leans
carelessly on the wheel of her martyrdom, which
curves inexorably towards the heavens where she
truly lives. This rapturous state is pure gift and not
for our seeking. (As soon as we seek, self comes in
and renders the whole thing useless.)

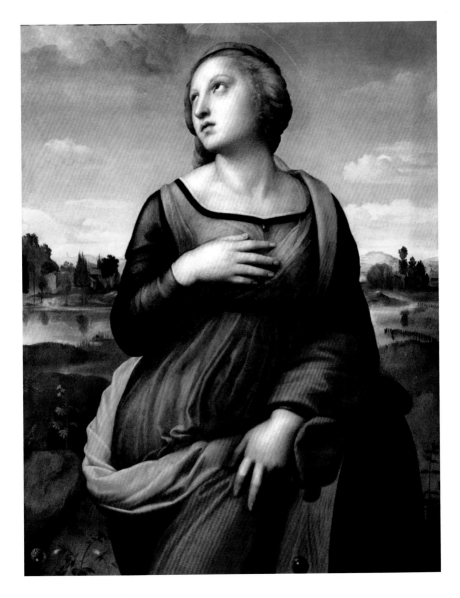

2

THURSDAY

A rich emptiness

Queen's House, Greenwich II, 1978,
Ben Johnson

Ben Johnson has taken as his special theme the way light shines on emptiness. The Queen's House, Greenwich is utterly still, utterly bare to our gaze. We are presented with a silent vista, not so much an invitation to advance through the arch and onwards as to stand motionless and simply contemplate. There is almost tangibly no sound, and what Johnson manages to suggest, implicitly, is that the richness is in the standing still, the non-acting. Just to be there, to take our smallness into this classical poise, is to become more potentially our true selves; it is not outer reality that is revealed, but our own innerness. Contemplation is essentially a surrender to the holiness of the divine mystery, whether we use these words or not. An atheist, calming his or her spirit in the peace of silence, is irradiated by the same mystery, anonymous but transforming.

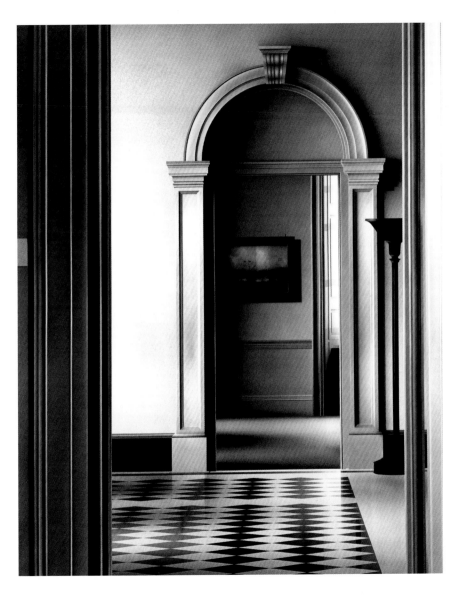

2

FRIDAY

Amid the chaos

Still Life with Ginger Pot II, 1911–12,
Piet Mondrian

To know what matters and what does not is the lesson that we long to be taught. Mondrian's *Still Life with Ginger Pot II* shows us a geometrical tangle of incoherent lines, which might or might not have a meaning. But at the centre of all this, pure, rounded and still, gleams the pot, the one satisfying certainty amid the existential chaos. It is only when we are still, when we open up to our inner reality, that the things in our life fall into coherence for us. We do not necessarily have to think this out: silence makes the order plain. But instead we quieten our restless minds, and then rise to find that we see, now, the essential.

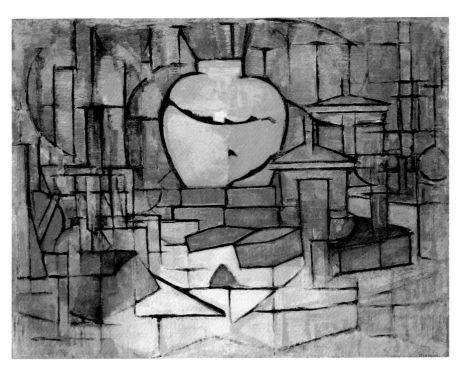

2

SATURDAY

A still life

White Lilac, 1882–83, Edouard Manet

In a crystal vase, bathed in sunlight, Manet's *White Lilac* has no function except to exist. In the last year of his life, wretchedly shortened through illness, Manet painted several of these vases of simple flowers. Their singleness of being must have moved him and perhaps consoled him, amid the anxieties and anguishes of his own pain-filled days. Contemplation has something of this function: a simplifying, a beautifying. It reminds us that we have only to be still and let the waters of grace refresh us and the sunlight of peace shine upon us.

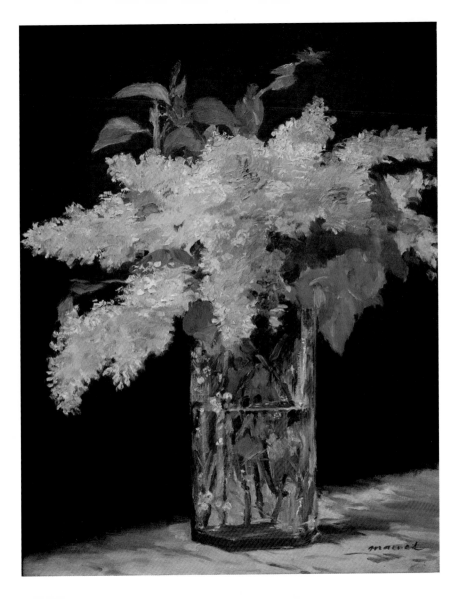

Third Sunday in Lent

Peace

The peace of God, which surpasses all understanding, will guard your hearts and minds in Christ Jesus.

PHILIPPIANS 4.7

3

MONDAY

Finding a balance

Composition in Red, Yellow and Blue,
1930, Piet Mondrian

True peace, dependent on nothing external, and hence wholly steadfast, comes from an inner balance between desire and potential. As long as we hunger for what we cannot have and battle hopelessly against what must always defeat us, we are not at peace. In case this sounds discouraging, the point is that it is not so much that we cannot have all we desire – and more – but that we have to align our desires in the truth. Our spirit is too great for small and specific happinesses: our potential is infinite. The secret of peace is determining where this infinitude is, and here is where the need for balance becomes paramount. In this painting Mondrian has used only three colours and a few black lines, and from their balance created a painting of the most subtle passion. Move a line or modify a rectangle, and the balance is lost and the painting becomes dull.

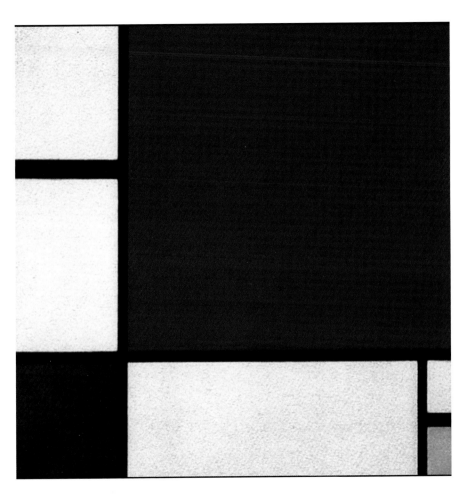

3

The illusion of peace

Amédée-David, Marquis de Pastoret,
1826, Jean-Auguste-Dominique Ingres

Good is not a judgement we can make about ourselves. We instinctively react against Ingres's young Marquis, who so obviously has a high opinion of himself. Whether he considers himself virtuous is not spelled out, but he stands before us with the restrained smirk of self-admiration. Those who are genuinely good always doubt their goodness. Peace does not depend upon anything, certainly not upon our own certainty of moral righteousness. It depends upon humble desire (with the emphasis on humble) to do what is right. Ingres's sitter, decorations prominent, simplicity of attire elegantly visible, hands electric with a sense of superiority, has a totally dependent kind of peace. Humiliation and failure would explode it, whereas true peace is impervious to events. Peace rests upon the decision always to struggle towards goodness, whatever our condition. In this light, one feels compassion for Amédée-David, with all his spiritual disadvantages.

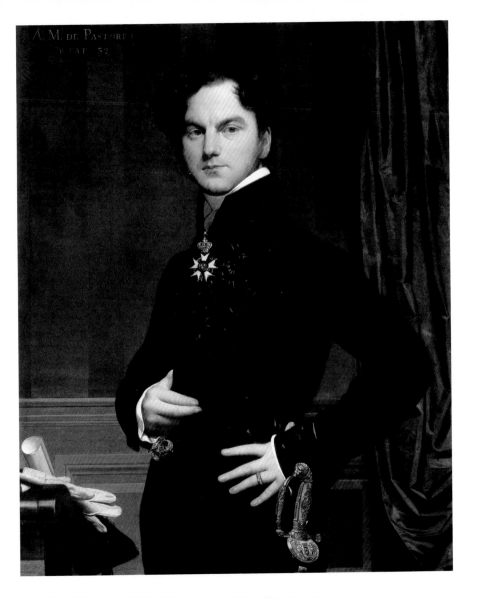

3

WEDNESDAY

Choosing peace

Interior, 1908, Vilhelm Hammershoi

An acceptance of the vulnerability on which peace is based, and the weighing of significance in the light of eternity, can seem to some an abdication from life's everyday realities. Hammershoi's woman sits in an enclosed space, head bent. She could be thought to be imprisoned by her context and weakly complicit with her lack of liberty. Yet the artist shows us door upon door, with a luminous window beyond. Light plays over the woman's form from behind as well as from ahead. If she chooses, she has only to stand erect and move down the waiting corridor. If she stays motionless (reading? sewing?), that is her choice. Peace is never imposed; it cannot be. It is a deliberate choice, an ordering of priorities in a moral context. We look at the options and evaluate them.

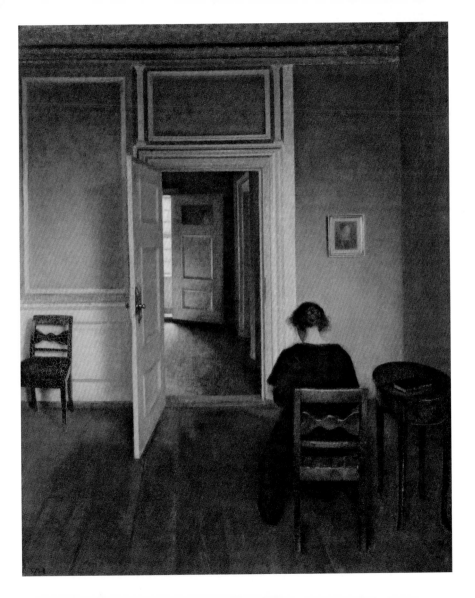

3 | **THURSDAY**

Isolation

The Silence, 1965, Carel Weight

The safety of peace has nothing at all to do with aloofness from other people, with keeping oneself free from the risk of emotional pain. Carel Weight's *The Silence* shows three people (almost three generations), motionless, silent, enclosed in their walled space, protected against the outside world and one another. Not one of them is at peace. They sit or stand stiffly, coldly, worryingly remote from family closeness. To isolate oneself is not to be at peace, and makes the acceptance of true life (which peace entails) impossible. Peace does not reject our longings, it is warm, not cold – a passionate commitment to becoming a full person. This means sacrificing the tidy goals of the fantasy person, one of which is that it is possible to live fruitfully in hostile isolation from our fellows.

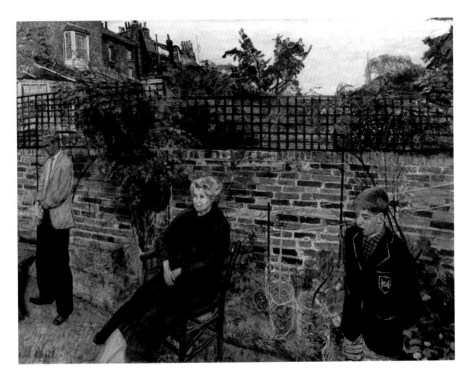

3

FRIDAY

Conditional peace

Allegory: Inconstancy, c.1490,
Giovanni Bellini

Bellini's allegories are not always easy to interpret, but this one clearly has as its theme uncertainty, inconstancy and insecurity. The globe balances precariously on the woman's knee, and its real support is the child, as likely as all the other children to grow tired of the task and take to frolicking. Any peace that rests upon externals is in such a state of insecurity. A good digestion, no financial trouble, happy relationships, an interesting career: then the world is beautiful to us, the children smile, and we are at peace. But of what value is such a peace? At any moment accident or natural change may disrupt it. A peace dependent on the woman's knee remaining still and the diligence of a small child in persisting in its Atlas-stance is a poor, uncertain peace: we cannot be peaceful in a dependence.

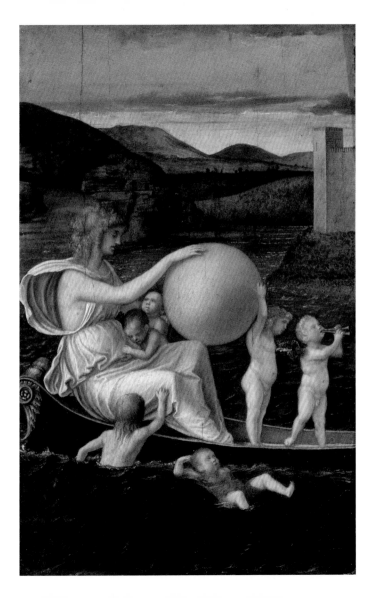

3

SATURDAY

A meaningful life

Annunciation, 1489–90, Sandro
Botticelli

We long for reassurance, our own personal angelic visit, the removal of obstacles, the certainty of fulfilment. Botticelli's Virgin sways in prayerful wonder as she receives the blessed summons. What will follow? For Mary it will be a life of loneliness and poverty, with her son dying a criminal's death and the only solace her faith. Human strengths can only lead to human satisfactions, and even these are vulnerable to fortune. But these are meagre goals, not enough to lead us into peace. There is no lasting peace that does not rest upon a sense of life having meaning. For Mary, that meaning was her divine Son; for others, it can come from a determination to do what is right, and the solid certainty that this is something that nobody can wrest away from us.

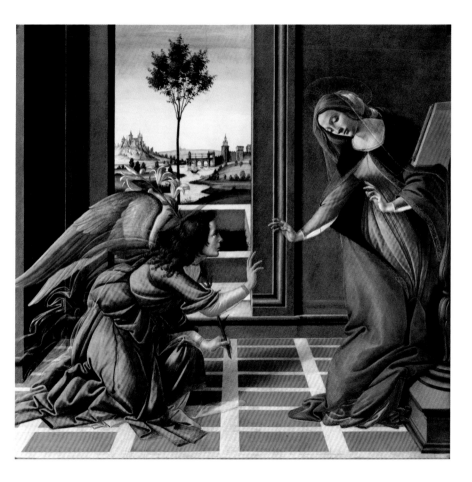

Joy

Weeping may linger for the night,
but joy comes with the morning.

PSALM 30.5

4

MONDAY

Choosing joy

Rainbow Landscape, c.1636, Peter Paul Rubens

Rubens is consummately the painter of happiness. But this sunlit, unreflecting sense of well-being, precious though it is, is not joy. Joy is something deeper, and in a sense sterner. Although we cannot command it, we choose joy, making a deliberate commitment to happiness (essentially another word for peace). Rubens delights in the positive: the rainbow symbolizing hope (and in itself so beautiful), the light glinting on the rich meadows, the benign cattle and their fruitful surroundings. Yet there are dark elements, too, in the picture if we want to seek them out: the sunless woods are not far away. Rubens chooses: he emphasizes the good things. Joy is independent of choosing: it overwhelms and suffuses us.

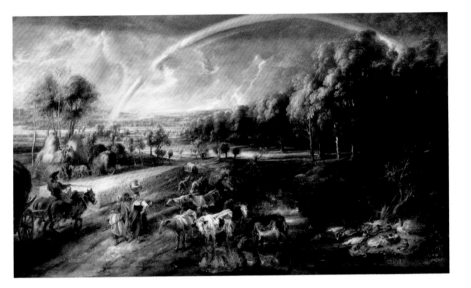

4

TUESDAY

Joy in infancy

Baby in Red Chair, c. 1810–30, unknown artist

The very small child, who is loved and protected, knowing nothing of the hazards of life, may know unreflecting joy. The anonymous American painter who saw this baby in Pennsylvania has painted a child enclosed and vulnerable, but wholly confident in love. The half-smile, the folded hands, the head resting on the oversized pillow: together these show one of the marks of joy: its absolute belief in what is experienced.

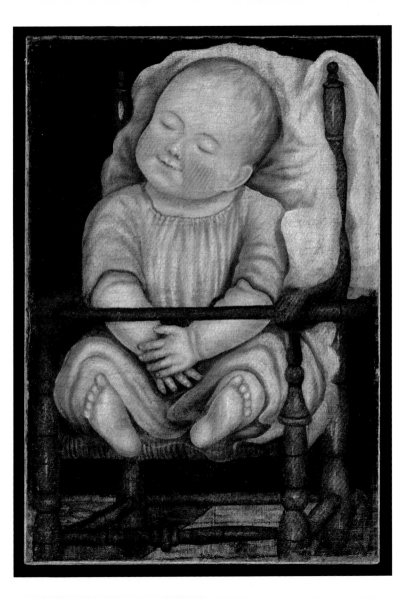

4

WEDNESDAY

Embracing joy

By Moonlight, 1994, Margaret Neve

We surrender to joy: we have no option. Margaret Neve's girl dances in the moonlight, resting upon the silky air as the great moon rests on the soft waters. She throws her arms out wide as if to float backwards, held up by pure joy. This gesture of embrace, opening as widely and welcomingly as is possible, marks the experience. Joy is felt as profoundly 'right', as what 'ought to be'. In grief, part of the pain comes from our feeling that we should not suffer so – that it is fundamentally alien to our being: this even though we all suffer, and frequently. Yet we reject suffering as a basic human truth, while greeting joy as integral to our very substance.

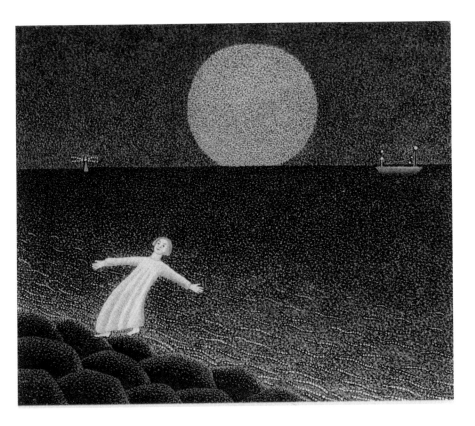

4

THURSDAY

Lost in time

Children on the Seashore, Guernsey,
1883?, Auguste Renoir

The way into blessed freedom may be not to live
in too great a dependence on the passage of time,
on the inexorable approach of tomorrow and
mortality. The sense of joy in Renoir's *Children on*
the Seashore seems to flow from the timelessness of
their experience. It is not a real world, with its softly
coloured pastel background made up of a blur of
bathers, and with the children themselves half melted
into their context of colour. They are responsive only
to the immediacy of their sun-filled leisure. We feel
that this holiday will be recalled, in the future, as joy,
though perhaps not yet fully realized as such.

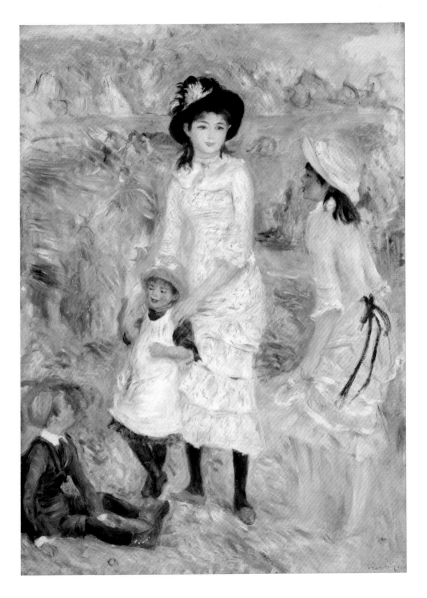

4

FRIDAY

Radiant truth

Pink Bowl with Grapes, 1992,
Craigie Aitchison

Regardless of the title of this painting, Craigie
Aitchison makes it clear to us that these are not
real grapes in a real bowl. The saturated colour,
so dazzlingly bright, affirms that this is the artist's
world, where grapes hang suspended in perfect
roundness against a clear scarlet background, and
where a two-coloured butterfly hovers exquisite in
the centre. This is so radiant a picture, so intense
in its certainties, that it seems to have, as its real,
hidden theme, the absoluteness of joy. There are no
half-measures here: it is the all-or-nothing that joy
reveals to us. There may be a dull brown lower layer,
but it is held firmly in its place, at the bottom, sat
upon by brightness. Only when overwhelmed by joy
do we know, in our very bodies, that this is the truth
of it.

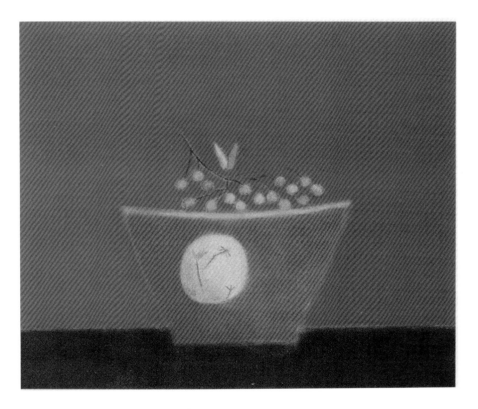

4

SATURDAY

Beyond experience

White Clematis, 1887, Claude Monet

It is inadequate, even misleading, to speak of 'experiencing joy', though it is impossible to find another phrase that can suggest what is meant. Joy is too great to be experienced. It is never our own, never within our power. It is rather that we are taken up into its vastness, and that what we experience is not joy itself but its residue: our reactions, our emotions, after the vision has left us. Monet's *White Clematis* says something of this, if only in its impression of a vision too vast for his encompassing. The blazing whiteness, with the shimmer of purest lemon yellow at the heart, spills out and beyond the artist's canvas. We feel that no canvas, however large, can capture what is seen. In the most literal sense, this is a painting of a vision; we recognize it, not for what it is, but for what it makes us recall.

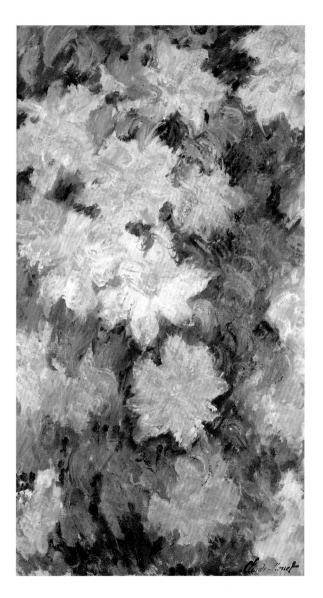

Fifth Sunday in Lent

Confidence

I rejoice, because I have complete confidence in you.

2 CORINTHIANS 7.16

5

MONDAY

A vision

Interior with Open Window, 1928,
Raoul Dufy

The experience of joy leaves behind it an awareness
of our personal freedom. Windows have opened
for us onto a vision that we cannot possess at will,
but which – having experienced pure joy – we now
know exists; and the windows remain open, even if
we must, for the present, stay within. Dufy's double
windows reveal the richness of the distant world,
its gleaming possibilities, its actuality. The space we
occupy may be as in the painting, cluttered and even
oppressive, but after joy it is no longer imprisoning.
We have glimpsed something greater, something
of liberating power, and we can have absolute
confidence that there are no external obstructions
to our movement out of limitation and into that
freedom.

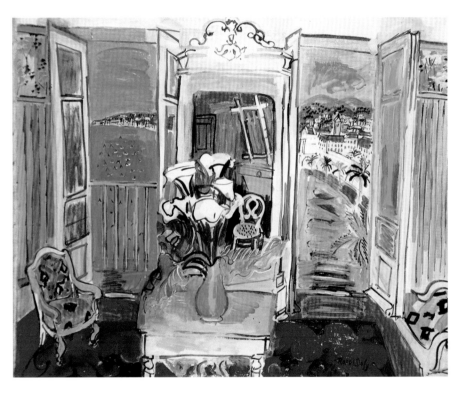

5

Joyful confidence

Diana the Huntress, c.1550, School
of Fontainebleau

When joy touches us it can seem a godlike
experience, suddenly making us aware of the eternal,
assuring us that we have nothing to fear, and that
the foundation of all being is Love. Like Diana the
huntress, we stride out uncluttered through the
morning sunlight. We need no covering for our feet:
they are met by tender grass and flowers. We need
no clothing, since in the world where joy has led us
there is no need for concealment. We may go naked
and unashamed, accepted for what we are. Outside
of joy, it takes very great confidence in another to
appear without protection, but here, there is only
vigorous and unencumbered movement forwards.
The dog – our animal nature – springs obediently
beside the virgin goddess, our spirit. Diana does not
even need to look where she is going: in her joyful
confidence there are no mistakes.

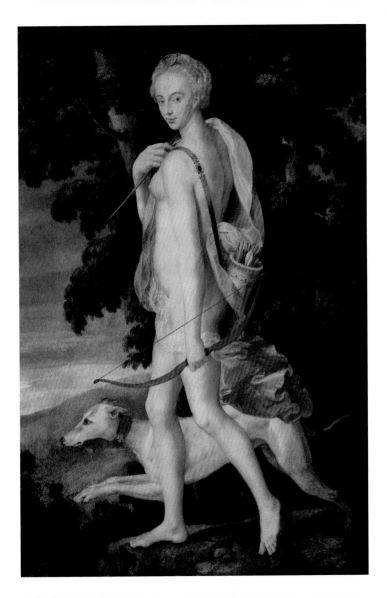

5

WEDNESDAY

Inner tranquillity

St Nicholas of Bari (detail from the
Ansidei Madonna), 1505, Raphael

Peace that demands unreal conditions is a deception.
There is no life without work, anxieties, or
tensions. Peace is not found in avoiding these but
in understanding them and confidently controlling
their force. One of the most tranquil faces in art is
Raphael's St Nicholas, an intensely active bishop.
The stories about his miracles may be legends,
but they attest to his great reputation for practical
involvement in the personal distresses of his people.
Even here, Raphael shows him not lost in silent
prayer but reading, with his crozier upright in his
hand. The unmistakable inner confidence we can
see has nothing at all to do with an unstressed life; it
comes from his insight into the significance of those
stresses, their value and their motivation.

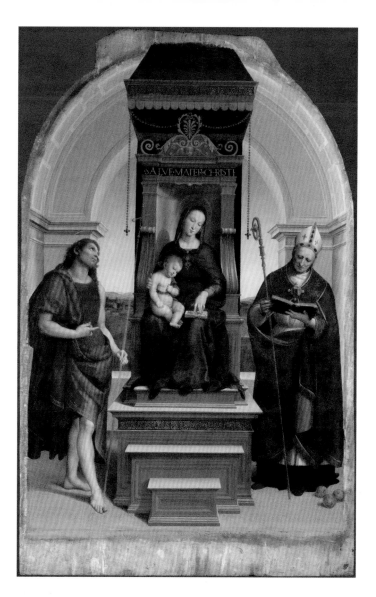

5

THURSDAY

Courage

Gilles, 1721, Jean-Antoine Watteau

Gilles is a man discomforted: he stands exposed, tense and unhappy. Yet we could not call him a man who is not at peace. Something has happened (Watteau does not spell it out) that has removed him from his fellow actors and left him painfully alone. Gilles is ill at ease, but he has no option: what is happening must be lived through, and he sets himself to do it. This courage – this acceptance of powerlessness and decision to await consequences from which we cannot escape – this is an element of the confidence that springs from peace. Gilles is at peace because he does not rage against the inevitable. The wisdom is in knowing what is inevitable and what, with courage and intelligence, can be changed. Fundamentally, though, nothing matters except to be true to what we know is right.

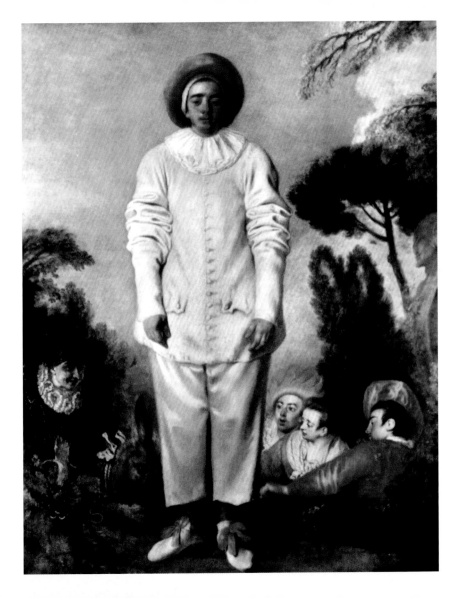

5

FRIDAY

A bright fortress

Seaside Residence II, 1994, Pia Stern

Pia Stern's *Seaside Residence II* shows a structure (a 'residence') on the very edge of the waves. They surge relentlessly towards it, almost, it seems, engulfing it; yet the structure stands. The unpredictability of the furrowed water, swaying inexorably inwards, does not substantially affect the 'residence'. It is a bright fortress, which apparently exists by other principles. If wild water is black and white, then the human home of the spirit is luminous with colour, bright enough to reflect onto the incoming waves, though not to deflect them. Stern shows us two ways of being: the physical, answerable only to accident, to wind and tide; and the spiritual, answerable to inward truth. One is free-flowing; the other is fixed, confident, grounded in more than its own small compass – in God.

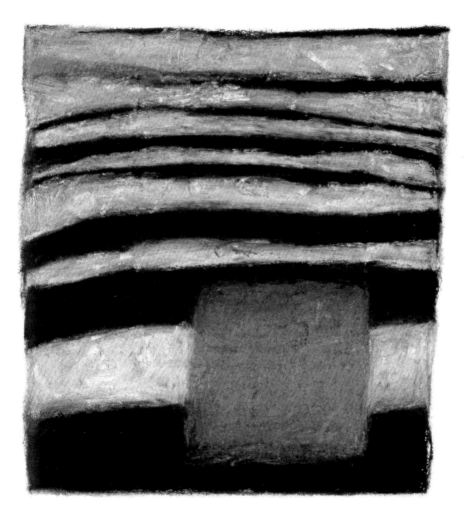

5

SATURDAY

Absolute trust

Sacrifice of Abraham, 1994, Albert
Herbert

The story of Abraham and his only son Isaac has always been a daunting one. Abraham believed that God was calling him to sacrifice his son, and he was saved from this hideous action only at the last minute. I have a personal reading of this story: to me the only one that makes sense. It is that God would never ask us to do something that is evil, and Abraham must have known this. So what we have is two gigantic acts of trust, each based upon knowledge of the other person, and of God. Abraham could only have gone ahead in the absolute confidence that the horror would never happen. Isaac, for his part, submitted to being bound and laid on the altar, believing against all appearances that his father would not harm him. If Abraham had not known God, if Isaac had not known his father, such confidence would have been madness. Love is not blind, despite the saying, and we cannot confidently give our hearts to the unknown. Love insists that we make a true judgement and then cleave to it, whatever the appearances.

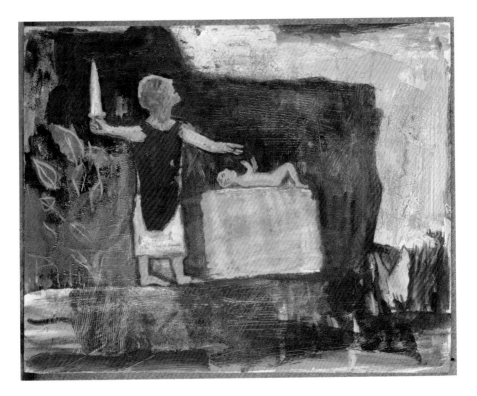

Palm Sunday

Love

No one has greater love than this,
to lay down one's life for one's friends.

JOHN 15.13

6

MONDAY

Tender reverence

The Jewish Bride (detail), 1665–67,
Rembrandt van Rijn

Reverence is the deepest form of respect, a serious
desire to recognize another as important in his or her
own right. It accepts that we are not central to the
universe. It is this attitude of tender humility that
Rembrandt expresses with such power in *The Jewish
Bride*. His couple are not in their first youth, or
beautiful in any classic sense, but both are infinitely
moving in their expression. We know at once that
they love each other. Each gives love and receives
it. Love is supremely beautiful, but like the golden
chain the man has placed around the neck of his
beloved, it also binds. Each is surrendering freedom,
but willingly so, thus facing the truth that we cannot
have everything; if we love, we make a delimiting
choice. They do not even need to look into each
other's eyes. Rather, they ponder with wonder the
implication of their blessedness and the meaning of
total commitment.

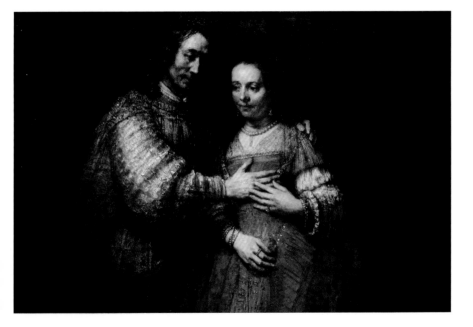

6

TUESDAY

Chasing the butterfly

Chasing the Butterfly, c.1775–76,
Thomas Gainsborough

Parental love is potentially its purest form, and may be the most painful. Gainsborough, whose marriage was unhappy, adored his two daughters, whom he called Molly and the Captain. Their mother's flawed psyche was inherited by both girls, and their father agonized over them all his life. Neither was to know happiness, and his many pictures of them show a sad foreknowledge of this. To leave those we love their independence, to accept that we cannot make their choices for them, that they cannot live by our hard-earned experience: this is part of love. We have to allow those dear to us to chase the butterfly, however convinced we are that it is uncatchable. We can never give the butterfly of happiness to another: each must catch it alone. For some, it will be ever elusive, and love must work within that painful understanding.

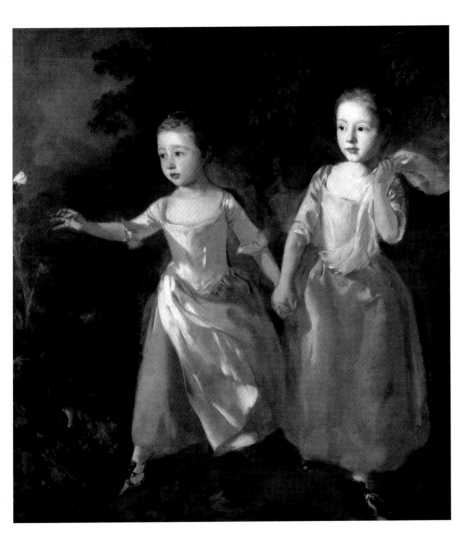

6

WEDNESDAY

Forgetting self

Camille on her Deathbed, 1879,
Claude Monet

It is extremely difficult to love unselfishly. We aspire to it, because the moment we subordinate the other's needs to our own, the moment we use them, we have, for that moment, ceased to love. Being selfish, a user, and regretting it, overcoming it, starting again; this is one of life's patterns. Death of a beloved can be an acid test; we are being abandoned, even if unintentionally. Utter concentration on the other in such a time of crisis is very rare. That is what makes Monet's picture so extraordinary. Camille was his wife; her early death left Monet not only bereft of her companionship but with small children now fully dependent on him. Obviously, Monet is to some extent escaping the pain by externalizing it, but it is, nonetheless, a remarkable act of egoless activity. He forgets himself in catching the least glimmer of light on his wife's face. In itself, this self-forgetfulness is the essence of true commitment.

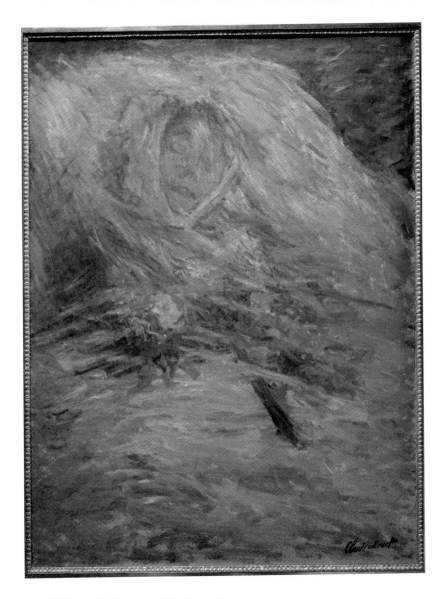

6

MAUNDY THURSDAY

No greater love

The Last Supper, 1497–98, Leonardo da Vinci

I find it sadly appropriate that the greatest of all Last Supper paintings, Leonardo's fresco in the monks' refectory in Milan, began to fade almost as soon as it was painted. Insatiable of experimentation, Leonardo tried an innovatory technique for this painting; it did not work, and restoration has been incessant ever since. Why I think this fresco's fading is appropriate is because what happened at the Last Supper exceeds our human understanding. Jesus gave his Church the Eucharist, a mystical means of communion with his risen body. If Christians received this Holy Communion just once in their lives, with what awed reverence they would prepare for that unimaginable moment. Yet, because the gift is offered at every Mass, we can miss the transforming power of this most holy sacrament. Leonardo shows the loneliness of Jesus. He is giving himself, crowning his life of loving sacrifice, yet the fresco shows the apostles as more concerned with his accusation of betrayal. That betrayal was almost incomprehensible, humanly speaking, yet the eucharistic gift is infinitely more mysterious.

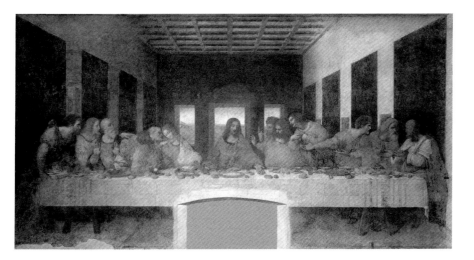

6

GOOD FRIDAY

Passionate sacrifice

Crucifixion, 2008, Craigie Aitchison

In art, there are few crucifixions that stress the inner truth of Jesus' death: that Christ accepted with enormous happiness that he had accomplished all that his Father willed.

Shortly before his death, Craigie Aitchison painted this extraordinary crucifixion. The world has been reduced to absolutes, in which only nature is innocent. The earth has become desert, and yet Jesus draws new life, the scarlet of a poppy. The very presence of the cross has created a strip of living green against which we can make out Aitchison's beloved Bedlington dog. But above the land soars Christ on the cross, a luminous body blazing with the fire of love. His features are consumed in the intensity of his passionate sacrifice. Over his head hovers the skeletal outline of the Holy Spirit. There are stars in the sky catching fire from the fire of Jesus, and we see the great curve of the rainbow, a sign of God's covenant with humankind. Aitchison is showing us not what the crucifixion looked like, but what it truly meant.

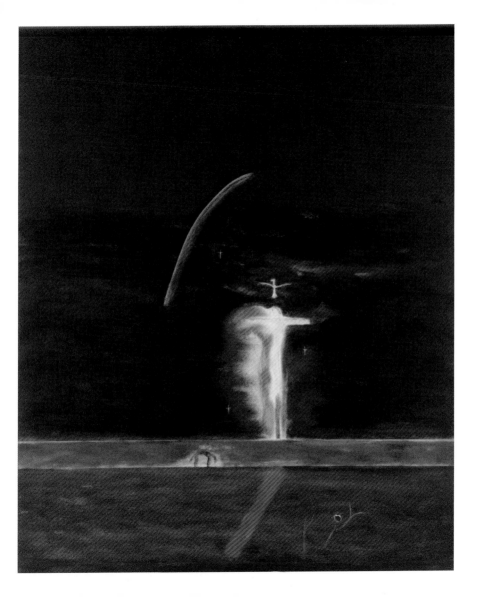

6

HOLY SATURDAY

Radiant expectation

Easter Saturday, 2010, Mark Cazalet

Easter Saturday, usually called Holy Saturday, can seem to be a non-day. The church is still in silence, the tabernacle is empty, there will not even be a Mass until late at night. Yet this is a day of the most radiant expectation. Think of the wonder of being on the brink of something you most long for: a birth, a wedding, a glorious fulfilment. It seems almost too good to be true, that tomorrow Jesus will rise from the dead and transform our lives. All we have longed for during Lent is about to come to an unimaginable climax of reality. Mark Cazalet draws with coloured chalk on paper to show a little clearing in the small wood near his Suffolk home. The light is ethereal. We know we are in the presence of something greater than we can see.

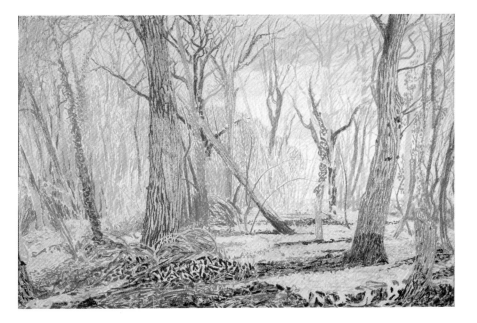

EASTER DAY

Resurrection

The Supper at Emmaus, 1601,
Michelangelo Merisi da Caravaggio

The central belief of Christianity is not that Jesus died, but that Jesus died and rose again. The two grieving disciples, with no notion of the resurrection, have the extraordinary experience of walking along the road to Emmaus, and hearing from an apparent stranger how the Messiah could only come to glory through suffering.

Engrossed by his conversation, the disciples begged him to join them for supper. It was only at the table, when Jesus blessed the bread and broke it, that they suddenly recognized him. Breaking the bread and blessing it: that is the Eucharist. For us, too, Jesus reveals himself in the 'breaking of bread', though as we expect it, we are not as astonished as these two men.

Better perhaps if we were astonished, because the Eucharist is the most sacred of gifts. Caravaggio does not paint Jesus as is customary: bearded, grave and compassionate of face. This is a Jesus who is eternally young, though still utterly the same.

O come, Lord Jesus, rise within us and take us to yourself.

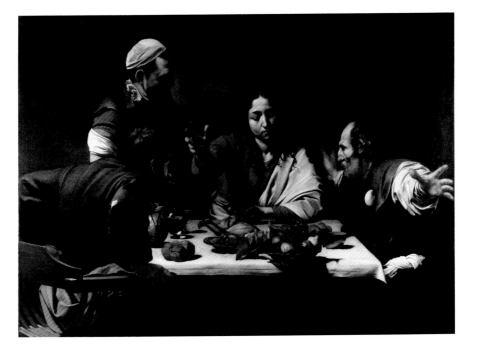

COPYRIGHT ACKNOWLEDGEMENTS